TOO LATE TO RESIST

Steamy Clinches from the Pulp Classics

A Pulp Postcard Book

PRION

First published in 2002 by

Prion Books Limited

Imperial Works

Perren Street

London NW5 3ED

Compilation © Prion Books 2002

All images from the Peter Chapman collection

ISBN 1-85375-485-5

Originated in Hong Kong by Fine Arts

Printed and bound in China

by Leo Paper Products

TOO LATE TO RESIST

PULP POSTCARDS Prion Books Ltd · Imperial Works, Perren Street, London NW5 3ED

The meek ran wanton and the wanton ran berserk

office party

party

by
DEAN
HUDSON

The meek
ran wanton
and wantons
ran berserk!

PULP POSTCARDS Prion Books Ltd Imperial Works, Perren Street, London NW5 3ED

TOO LATE TO RESIST

Her best friends were diamonds and men

No Angels For Me

William Ard

Author of

"A PRIVATE PARTY"

PULP POSTCARDS Prion Books Ltd Imperial Works, Perren Street, London NW5 3ED

TOO LATE TO RESIST

Janice put her body on the block

Janice put her body on the block as —

The PAYOFF

She made the first payment in his office

By MAX COLLIER
author of "THORN OF EVIL"

TOO LATE TO RESIST
PULP POSTCARDS Prion Books Ltd Imperial Works, Perren Street, London NW5 3ED

The well-heeled women who go to sea for thrills

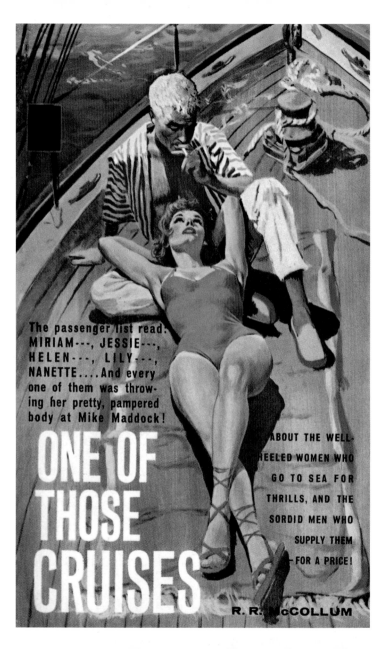

The passenger list read:
MIRIAM---, JESSIE---,
HELEN---, LILY---,
NANETTE....And every
one of them was throw-
ing her pretty, pampered
body at Mike Maddock!

ONE OF THOSE CRUISES

ABOUT THE WELL-
HEELED WOMEN WHO
GO TO SEA FOR
THRILLS, AND THE
SORDID MEN WHO
SUPPLY THEM
—FOR A PRICE!

R. R. McCOLLUM

PULP POSTCARDS PRION BOOKS LTD IMPERIAL WORKS, PERREN STREET, LONDON NW5 3ED

TOO LATE TO RESIST

When a girl boarded Tony's yacht, she knew what to expect

FLOATING BEDROOM

SEYMOUR SHUBIN

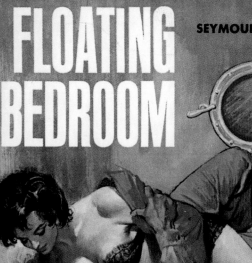

"If you've ever wondered
what actually happens on one
of those society
private yachting cruises,
wonder no longer.
This book scorches out
the answer...!" *L. S. Shaw*

**A scandalous, sensational best-seller in England,
now published here for the first time.**

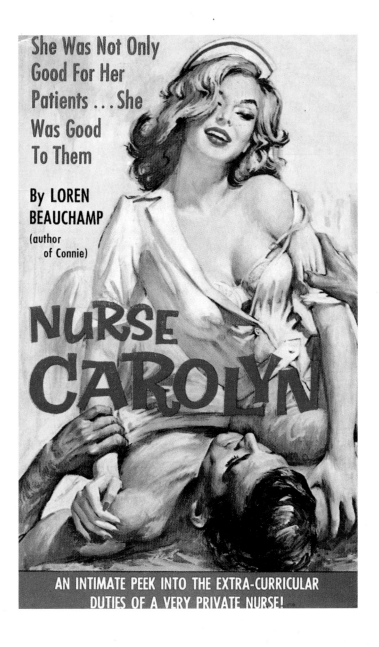

She Was Not Only
Good For Her
Patients ... She
Was Good
To Them

By LOREN
BEAUCHAMP

(author
of Connie)

NURSE
CAROLYN

AN INTIMATE PEEK INTO THE EXTRA-CURRICULAR
DUTIES OF A VERY PRIVATE NURSE!

PULP POSTCARDS PRION BOOKS LTD IMPERIAL WORKS, PERREN STREET, LONDON NW5 3ED
TOO LATE TO RESIST

She was not only good for her patients...she was good to them

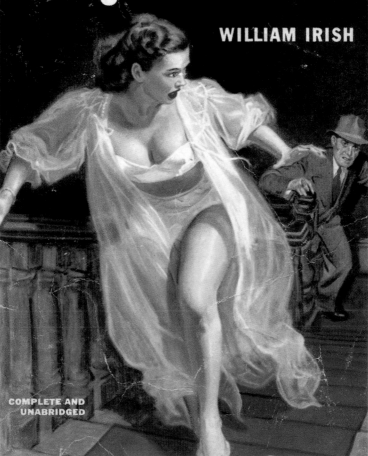

The Killer Was Crazy—About Women

Strangler's Serenade

WILLIAM IRISH

COMPLETE AND
UNABRIDGED

PRION

PULP POSTCARDS Prion Books Ltd Imperial Works, Perren Street, London NW5 3ED

TOO LATE TO RESIST

The killer was crazy – about women

JUANITA'S PRIMITIVE TWISTS ON THE DANCE FLOOR WERE ONLY A SAMPLE OF WHAT SHE WANTED TO GIVE!

the sex twist

JOHN CARVER

Brent thought dance fads were kid stuff until he found that the "kids" went looking for bigger thrills after the music stopped!

TOO LATE TO RESIST

PULP POSTCARDS Prion Books Ltd Imperial Works, Perren Street, London NW5 3ED

Juanita's primitive twists on the dance floor were only a sample

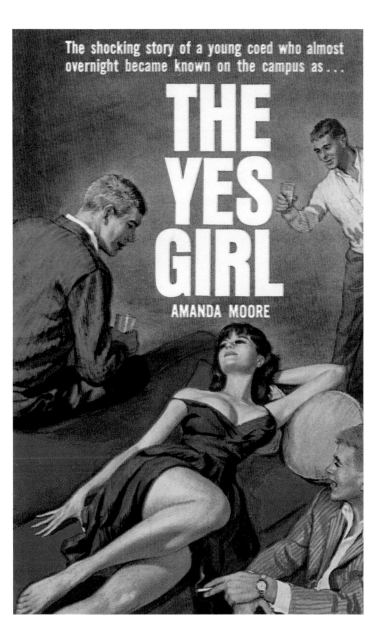

The shocking story of a young coed who almost overnight became known on the campus as...

THE YES GIRL

AMANDA MOORE

PULP POSTCARDS PRION BOOKS LTD IMPERIAL WORKS, PERREN STREET, LONDON NW5 3ED
TOO LATE TO RESIST

The shocking story of a young coed

ARE AIRLINE HOSTESSES HARD TO GET? CYNTHIA WESTLAND WASN'T!

FLY GIRL

When a jet-powered hostess and a hot pilot lock horns,
no holds are barred
and the sky's the limit...

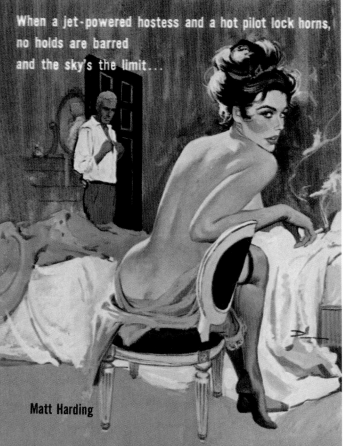

Matt Harding

**HERE IS THE FRANKLY TOLD STORY OF THE GIRLS
WHO LIVE DANGEROUSLY—AND LOVE RECKLESSLY!**

PULP POSTCARDS Prion Books Ltd Imperial Works, Perren Street, London NW5 3ED

TOO LATE TO RESIST

When a jet-powered hostess and a hot pilot lock horns

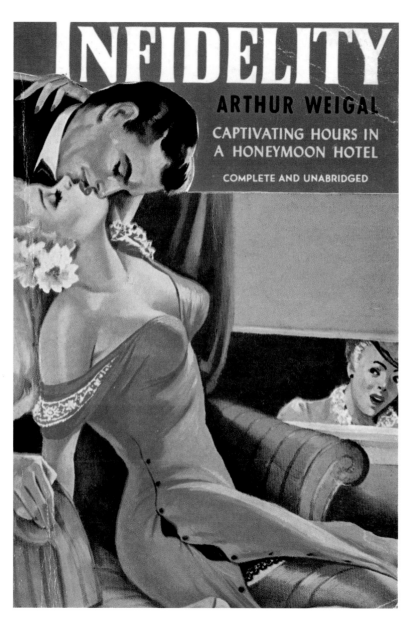

INFIDELITY

ARTHUR WEIGAL

CAPTIVATING HOURS IN
A HONEYMOON HOTEL

COMPLETE AND UNABRIDGED

PULP POSTCARDS Prion Books Ltd Imperial Works, Perren Street, London NW5 3ED

TOO LATE TO RESIST

Captivating hours in a honeymoon hotel

She had been a virgin too long
to understand her —

Sudden Hunger

By PAUL DODGE

PRION

TOO LATE TO RESIST

PULP POSTCARDS Prion Books Ltd Imperial Works, Perren Street, London NW5 3ED

She had been a virgin too long

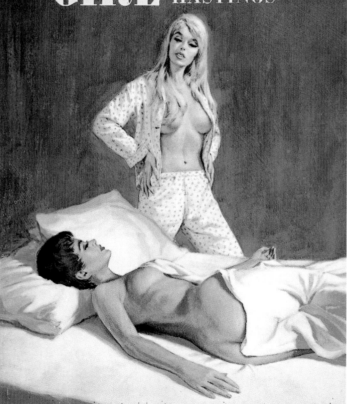

Addie was man crazy until
Margo showed her that man-
woman love isn't everything.

ANYBODY'S
GIRL MARCH
HASTINGS

TOO LATE TO RESIST

PULP POSTCARDS Prion Books Ltd Imperial Works, Perren Street, London NW5 3ED

Addie was man crazy until…

You've seen them in their sleek sports cars.
They have husbands by night and clients by day . . .

Shopping Center Sex

Oren A. Lang

At long last!
A novel that cuts to the corrupt
heart of suburbia's most shocking scandal!

NEVER BEFORE PUBLISHED

TOO LATE TO RESIST

PULP POSTCARDS Prion Books Ltd Imperial Works, Perren Street, London NW5 3ED

The corrupt heart of suburbia

Love And Violence In A City Jungle

COME AND GET ME

JOHNNY LAREDO

"A rough, tough, realistic tale of rapture and revenge in a corrupt town."
REAL MAGAZINE

Complete and Unabridged

TOO LATE TO RESIST

PULP POSTCARDS Prion Books Ltd Imperial Works, Perren Street, London NW5 3ED

Love and violence in a city jungle

STRANGE
EMBRACE

BEN
CHRISTOPHER

What unholy bonds
held two beautiful
actresses in a drama
that had no part
for male actors?

NEVER BEFORE PUBLISHED! A BRILLIANT NOVEL
ABOUT THE LOVE SOCIETY RECOGNIZES
BUT CANNOT FORGIVE!

PRION

TOO LATE TO RESIST
PULP POSTCARDS Prion Books Ltd Imperial Works, Perren Street, London NW5 3ED

No part for male actors

AFRAID in the DARK

Mark Derby

TOO LATE TO RESIST

PULP POSTCARDS Prion Books Ltd Imperial Works, Perren Street, London NW5 3ED

Vengeance and passion in exotic Malaya

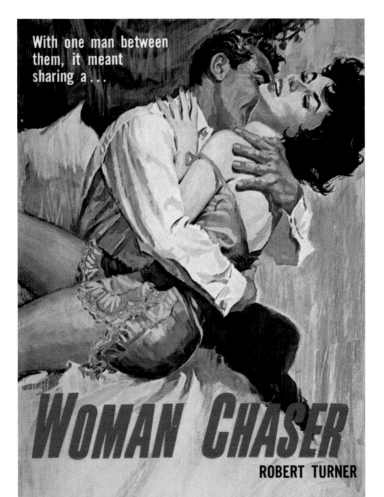

With one man between
them, it meant
sharing a . . .

WOMAN CHASER

ROBERT TURNER

Fay wanted Jack Buckman at home.
Smoldering-eyed Angie wanted him anywhere.
But Jack wanted to make time
—with Myrna, Monica, Juanita . . .
or any woman from <u>A</u>ngie to <u>Z</u>elda!

A NOVEL OF THE THREAT OF TODAY'S OTHER WOMEN

TOO LATE TO RESIST

PULP POSTCARDS Prion Books Ltd Imperial Works, Perren Street, London NW5 3ED

PRION

Any woman from Angie to Zelda

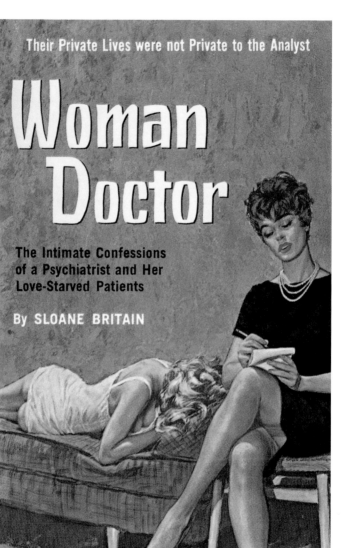

Their Private Lives were not Private to the Analyst

Woman Doctor

**The Intimate Confessions
of a Psychiatrist and Her
Love-Starved Patients**

By SLOANE BRITAIN

TOO LATE TO RESIST

PULP POSTCARDS PRION BOOKS LTD IMPERIAL WORKS, PERREN STREET, LONDON NW5 3ED

Intimate confessions of a psychiatrist

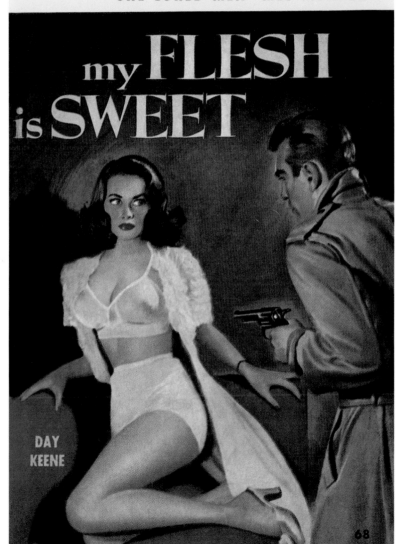

SHE LURED MEN—MET MURDER

my FLESH is SWEET

DAY KEENE

68

TOO LATE TO RESIST
PULP POSTCARDS Prion Books Ltd Imperial Works, Perren Street, London NW5 3ED

She lured men, met murder

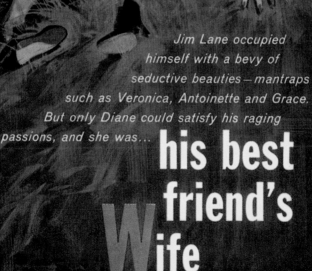

Jim Lane occupied
himself with a bevy of
seductive beauties — mantraps
such as Veronica, Antoinette and Grace.
But only Diane could satisfy his raging
passions, and she was...

his best friend's Wife

MARGARET CARRUTHERS

TOO LATE TO RESIST

PULP POSTCARDS Prion Books Ltd Imperial Works, Perren Street, London NW5 3ED

Only Diane could satisfy his raging passions...

TWISTED DESIRES SHAPED THE STRANGE LIVES OF —

THE
SENSUALISTS
BY ALAN MARSHALL

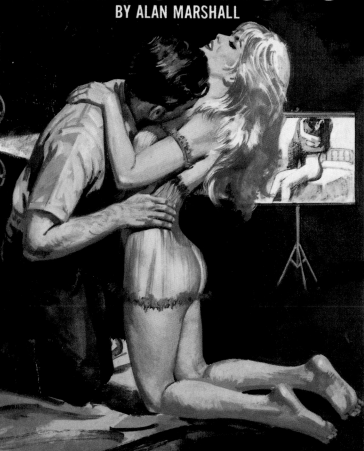

TOO LATE TO RESIST

PULP POSTCARDS Prion Books Ltd Imperial Works, Perren Street, London NW5 3ED

Twisted desires shaped strange lives

THERE WERE NO LENGTHS TO WHICH THIS WOMAN
WOULD NOT GO TO KEEP THIS BOY IN HER ARMS!

Boy-Lover

... Jack had heard
about women like her.
He knew now
that the call
to fix her car
was an excuse.
He stood there
just a few feet away,
drinking in
her golden loveliness,
and his
better judgment was
no match for
the burning desire
she so deliberately
lit in him ...

ALEX CARTER

TOO LATE TO RESIST

PULP POSTCARDS Prion Books Ltd Imperial Works, Perren Street, London NW5 3ED

Jack had heard about women like her